Copyright © Sandra Bacon. All Rights Reserved

No part of this publication may be reproduced, stored in a retrieval system or transmitted in any way or by any means. This means electronic, mechanical, photocopying, recording or otherwise, without the prior written consent of the author of this publication. Any person or persons who do may be liable to criminal prosecution and civil claims for damages.

Attribution 1:

Six of these drawings are licensed under Creative Commons Attribution-ShareAlike 4.0 International License

Attribution 2:

Images on pages 41 through 50 are From © GraphicsFactory.com

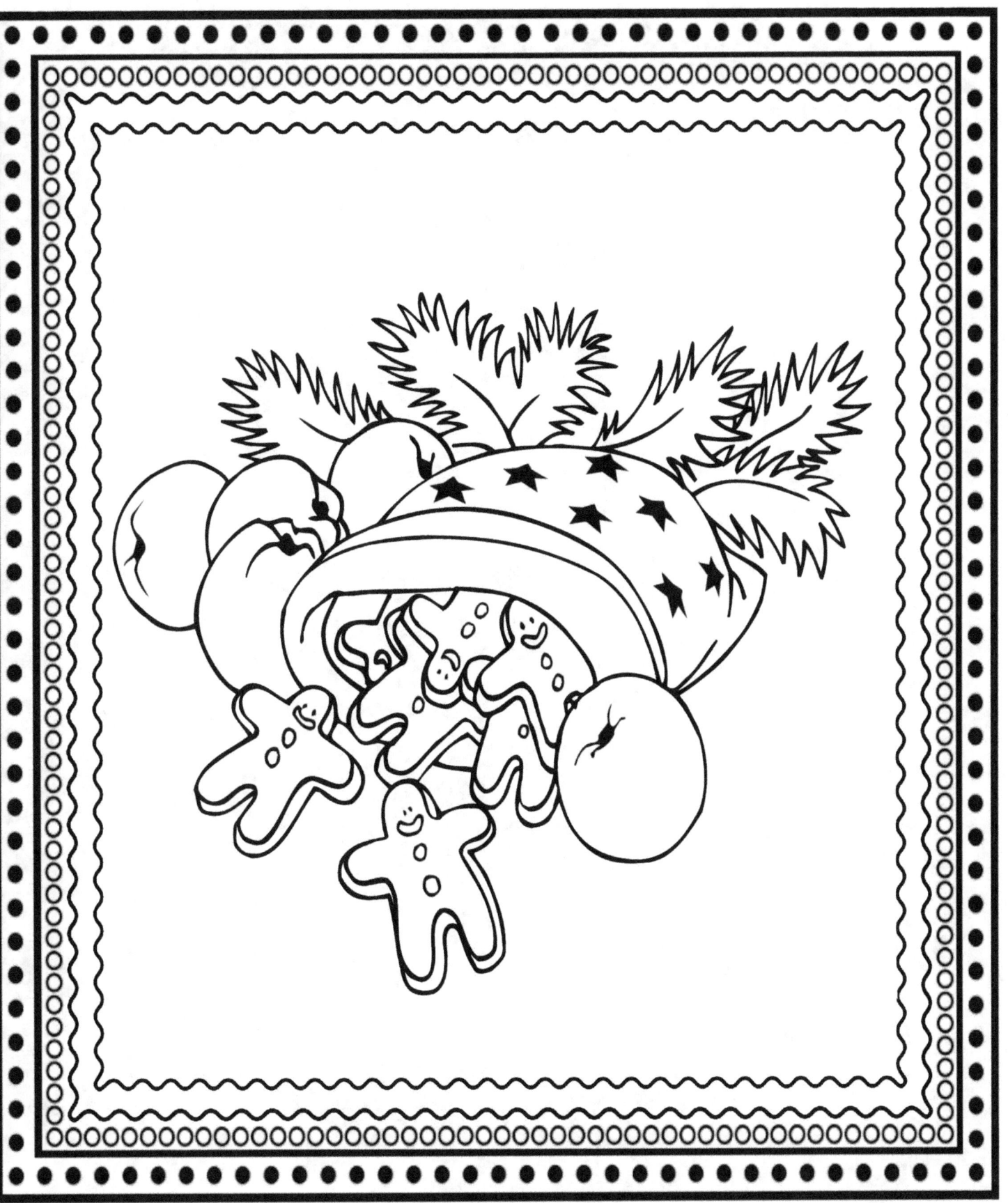

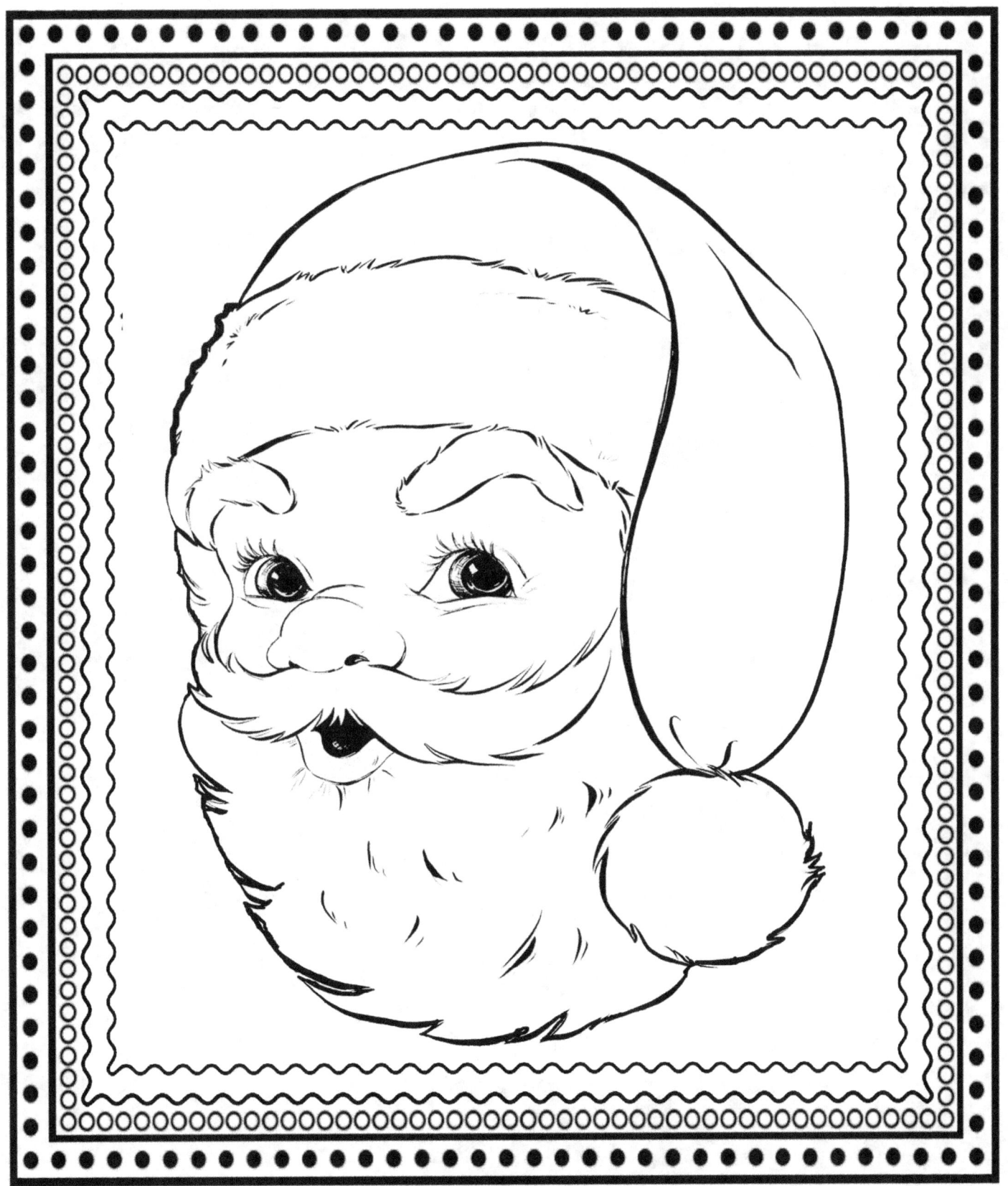

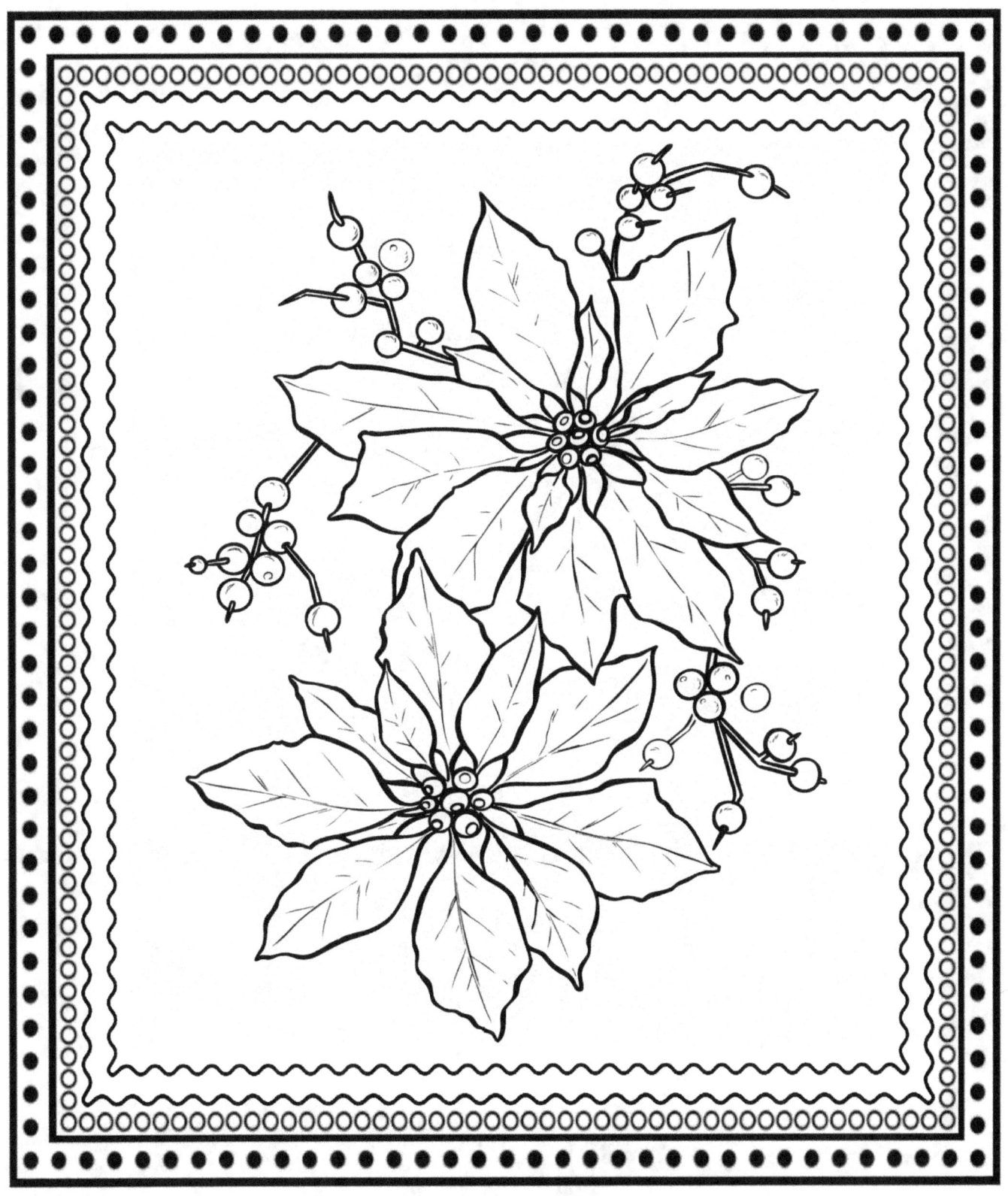

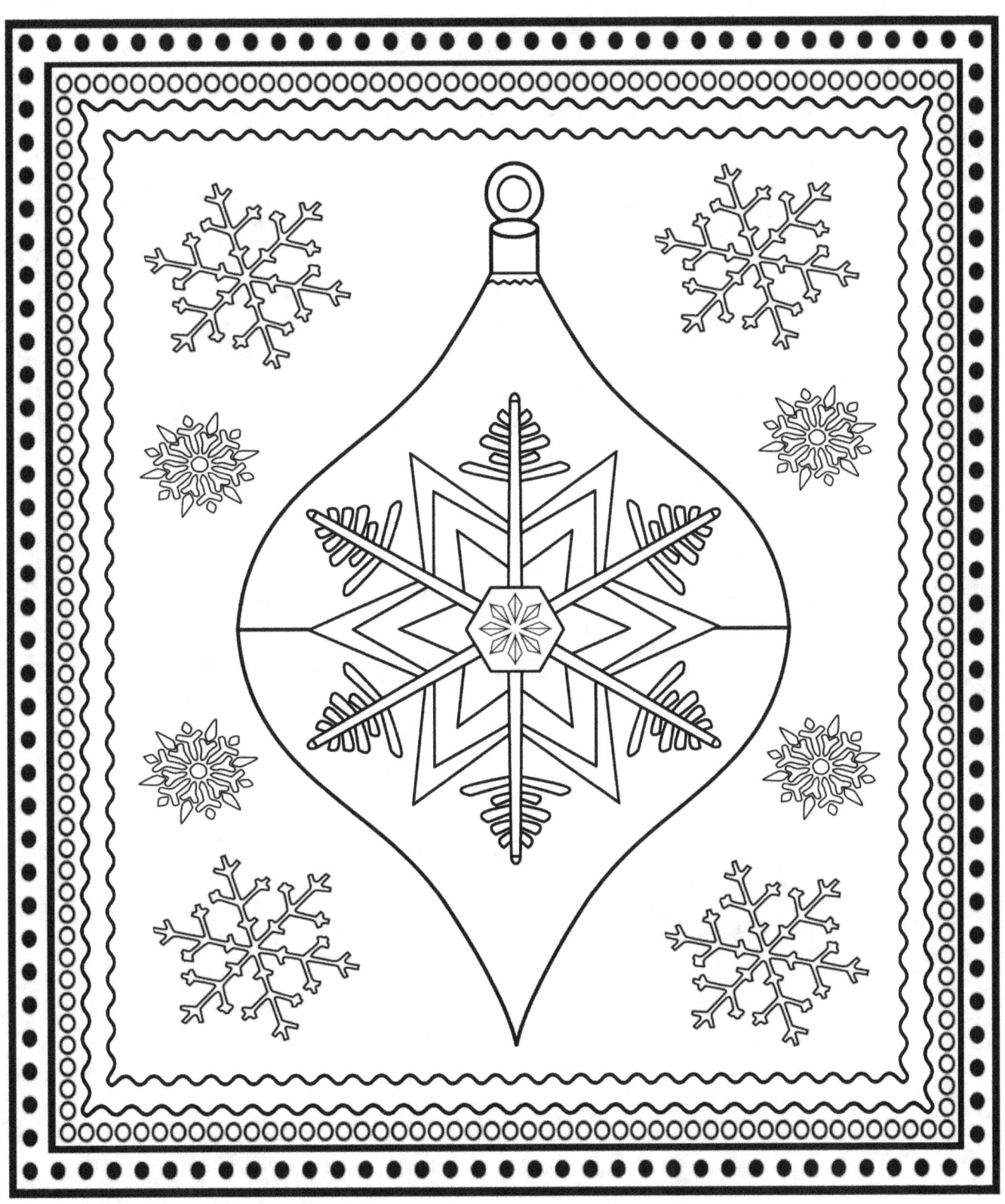

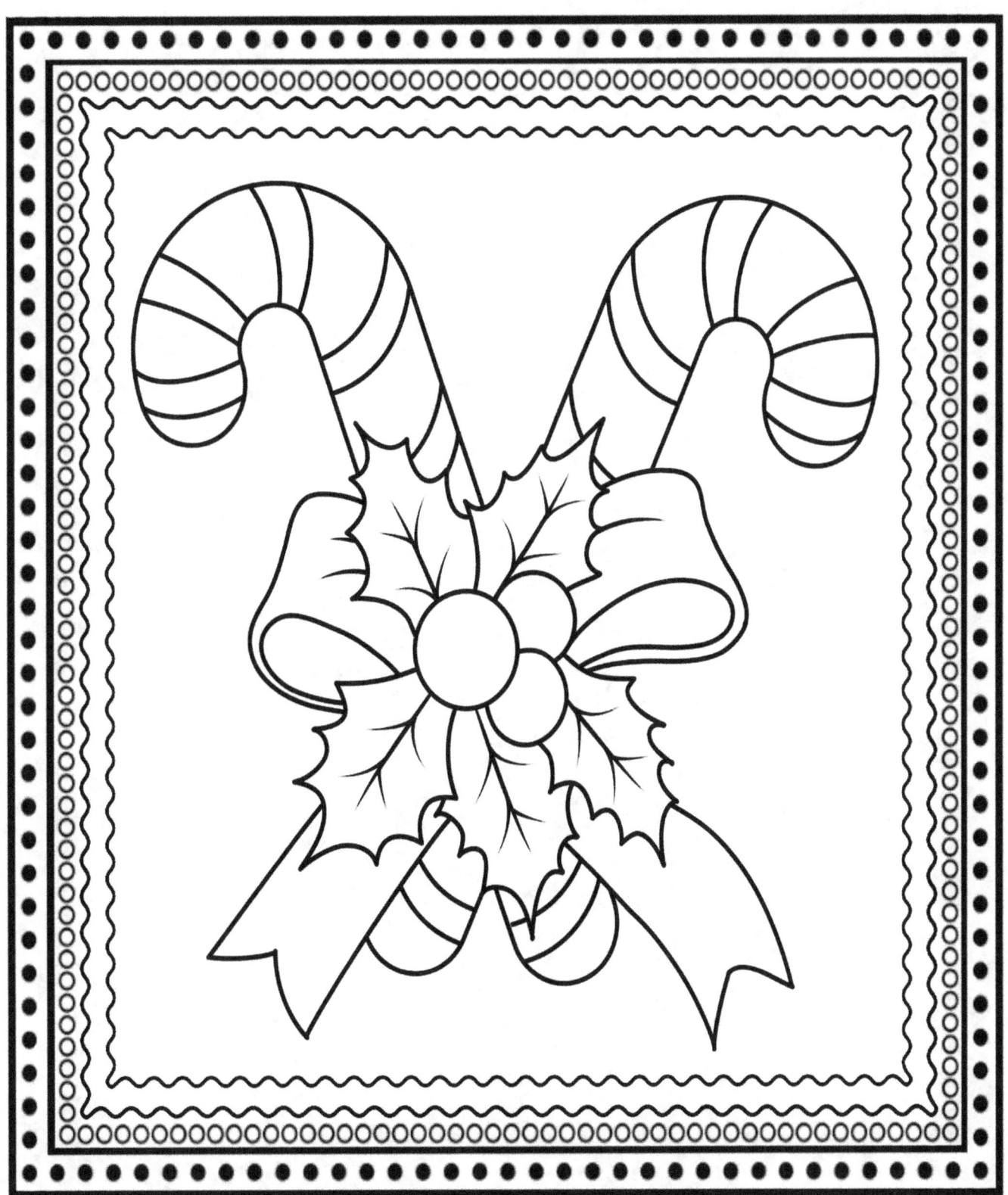

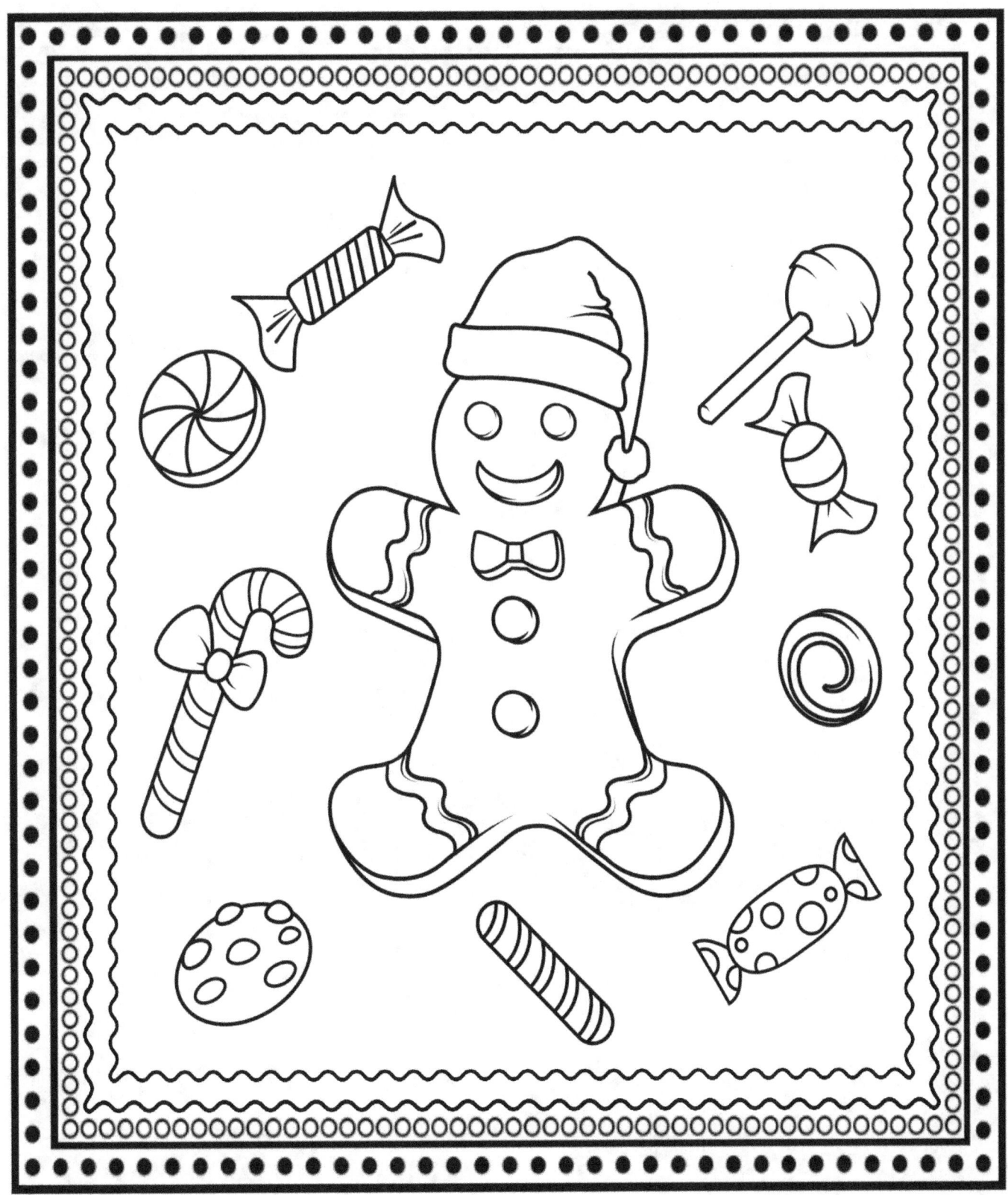

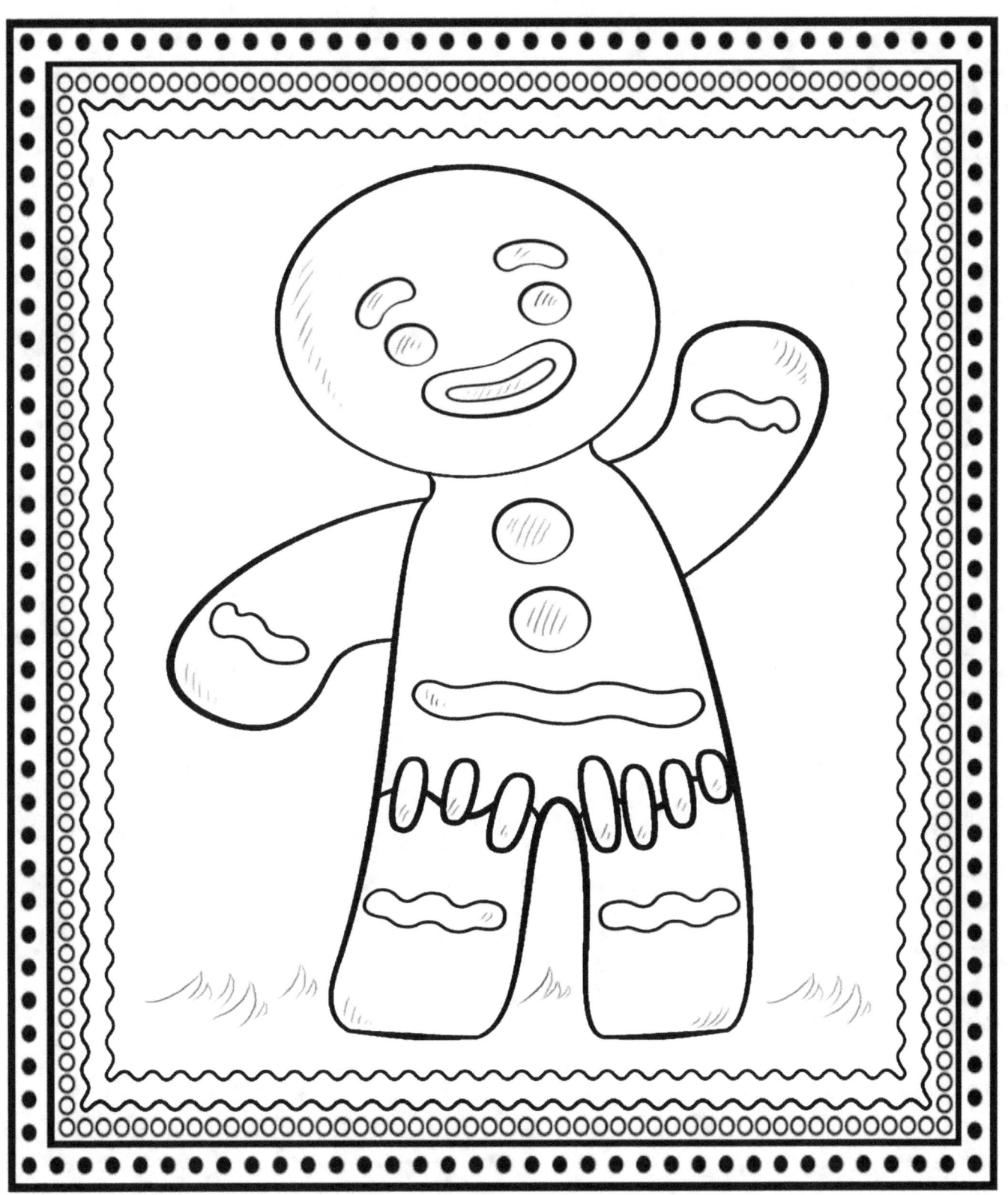

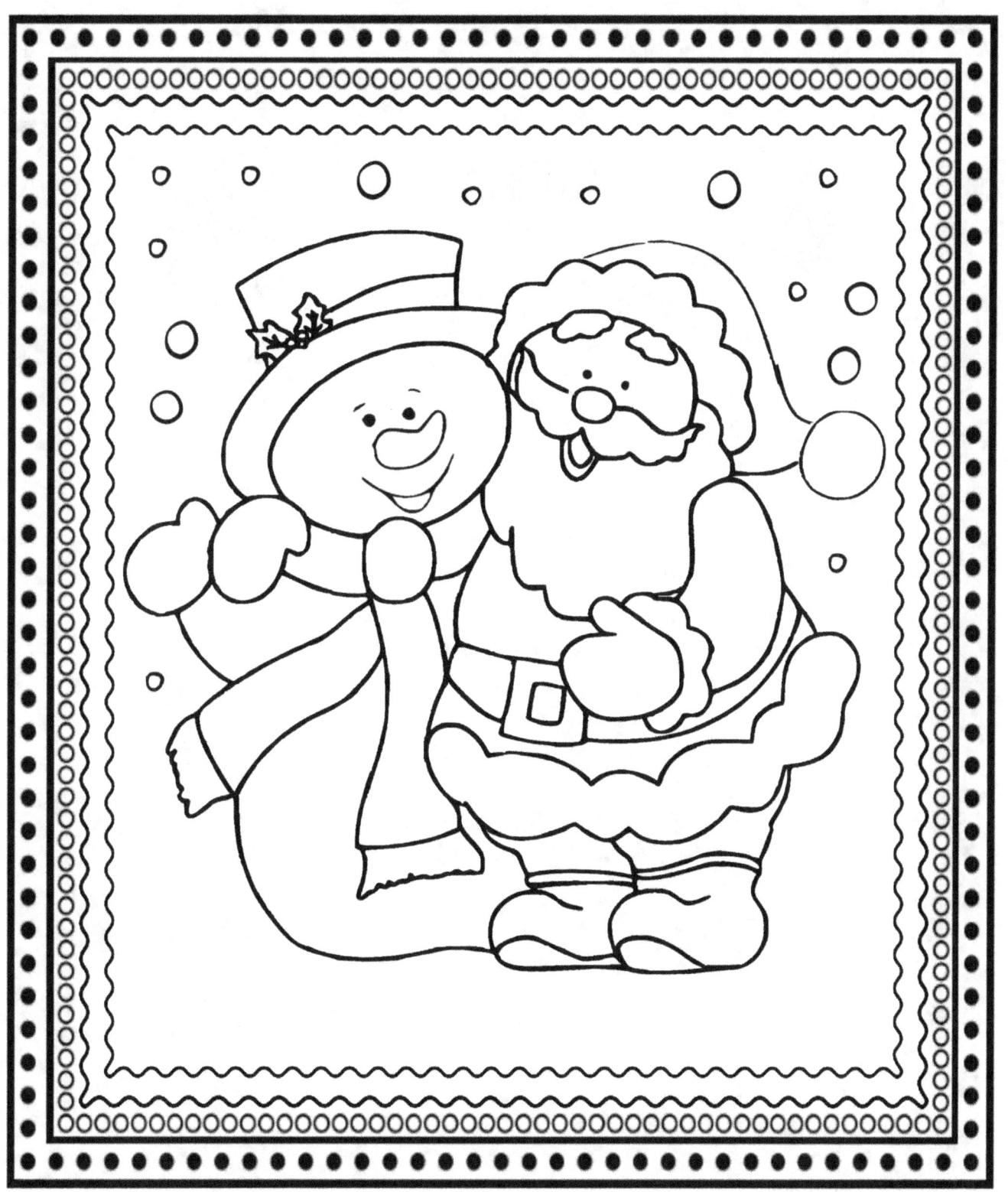

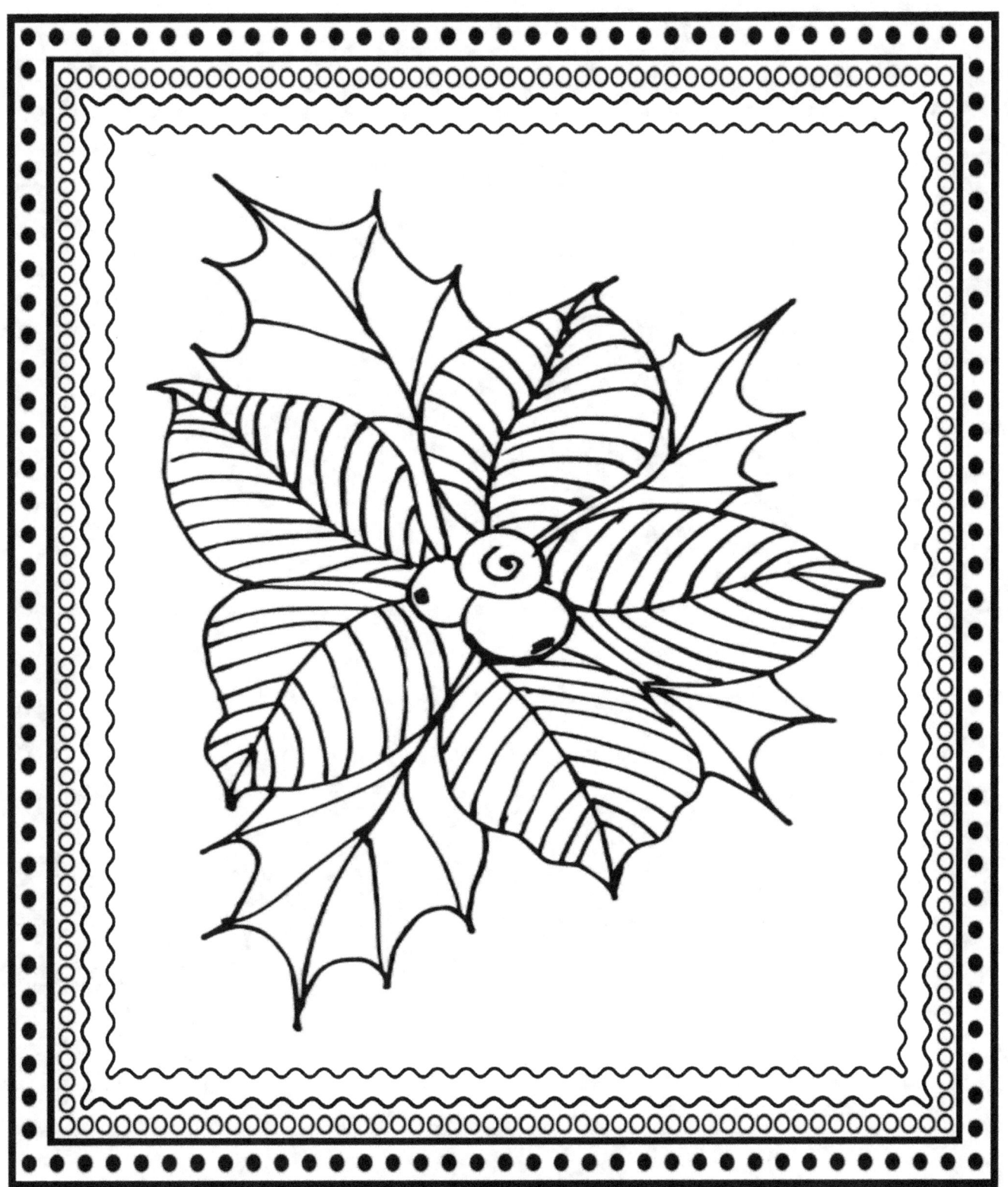

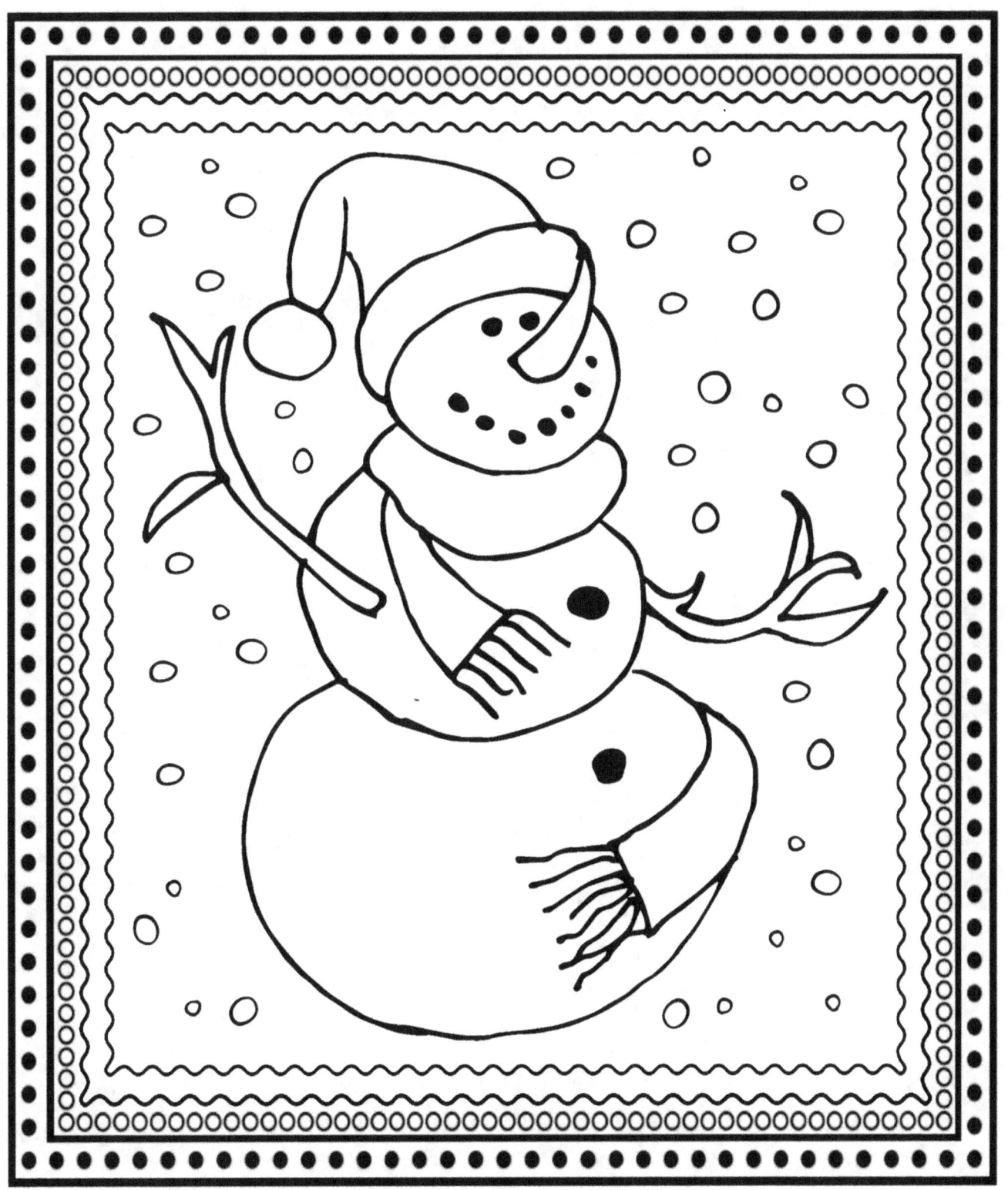

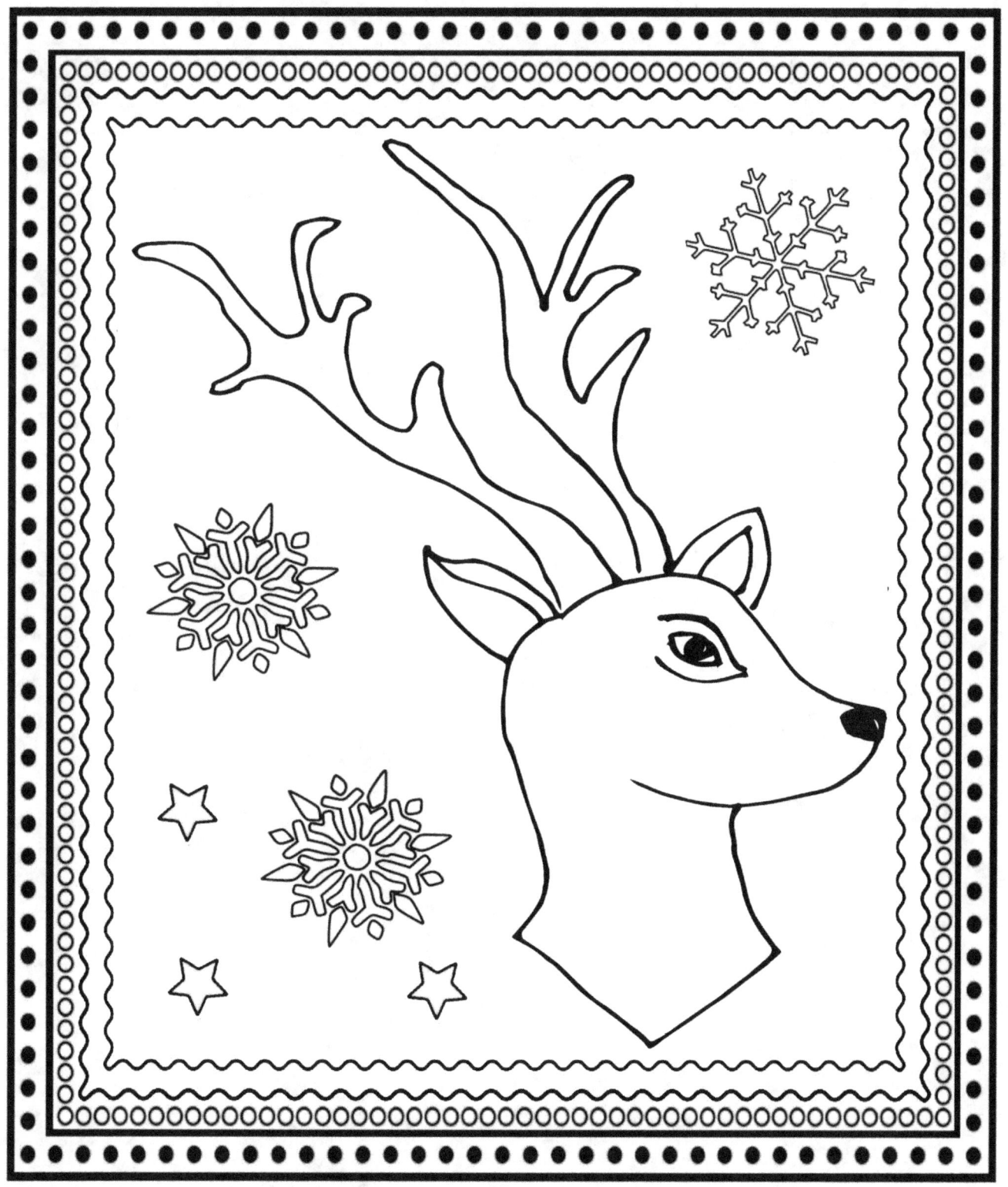

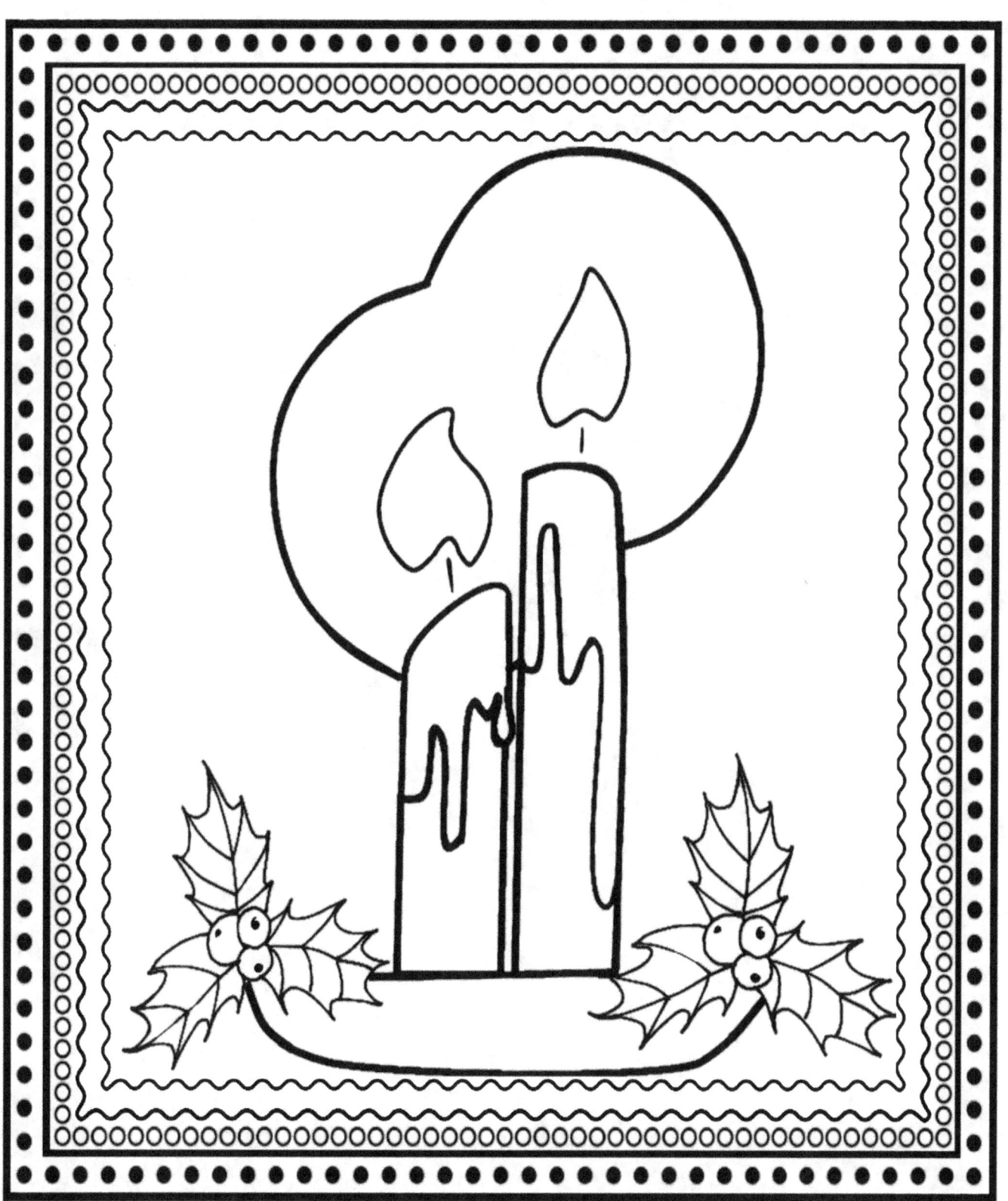

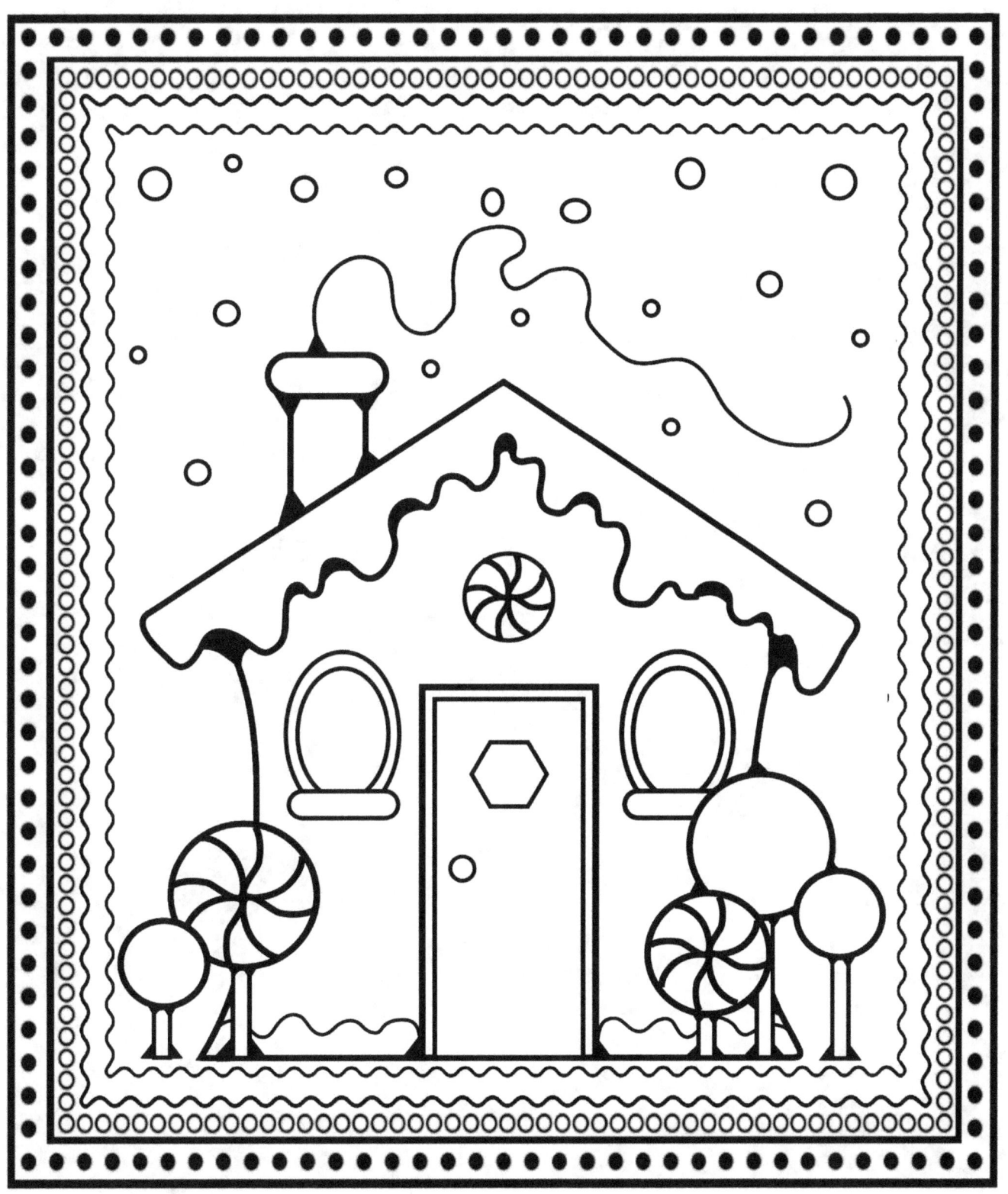

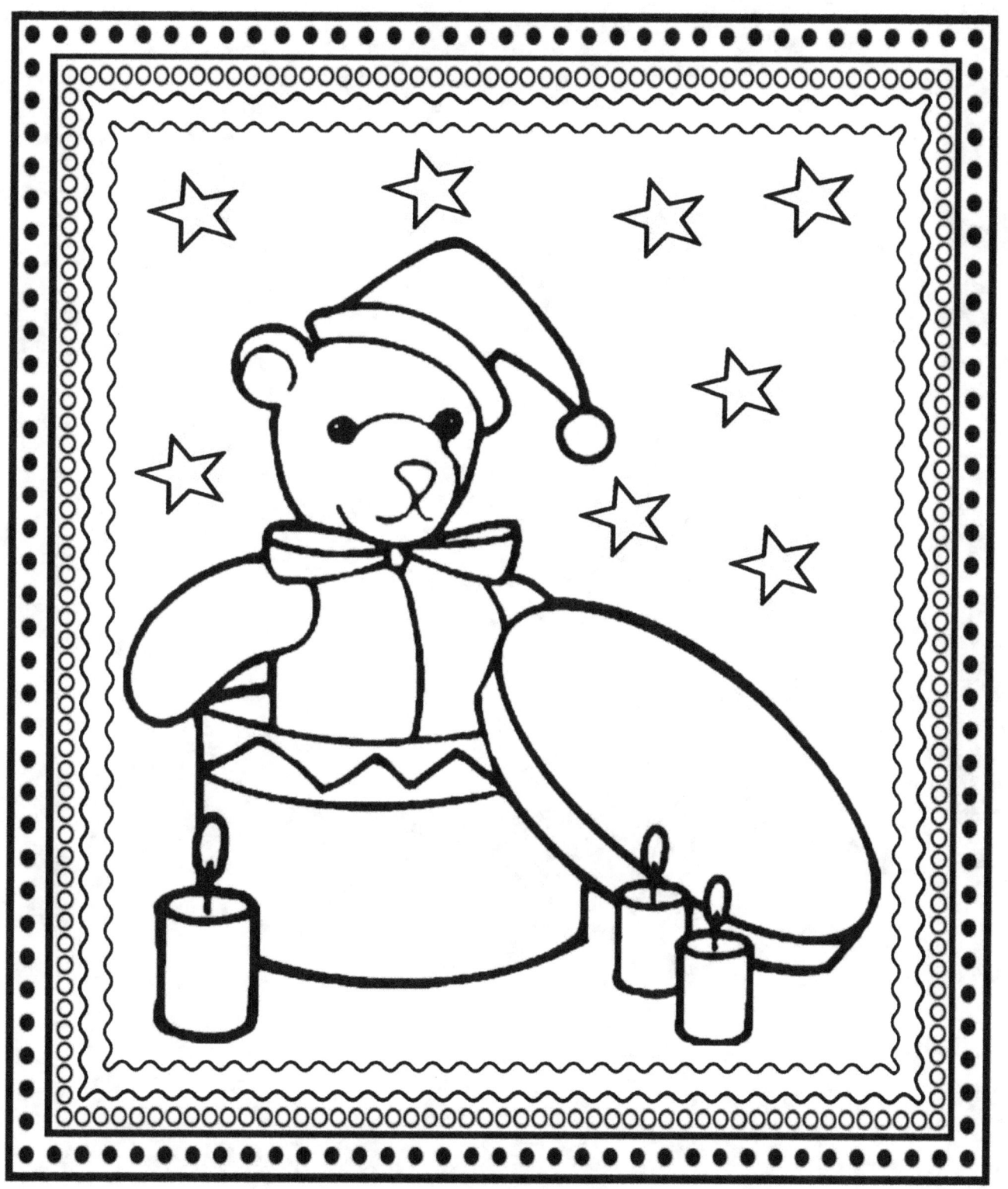

www.ingramcontent.com/pod-product-compliance
Lightning Source LLC
Chambersburg PA
CBHW081449220526
45466CB00008B/2568